Middle Street, Yeovil

YEOVIL
HISTORY TOUR

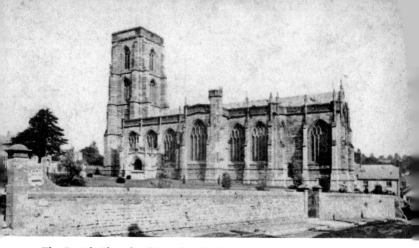

The Parish Church of St. John the Baptist, seen here *c.* 1875.

Map contains Ordnance Survey data © Crown Copyright and datatbase right [2015]

First published 2009
This edition published 2015

Amberley Publishing
The Hill, Stroud,
Gloucestershire, GL5 4EP
www.amberley-books.com

The right of Robin Ansell and
Jack Sweet to be identified as the
Author of this work has been asserted
in accordance with the Copyrights,
Designs and Patents Act 1988.

ISBN 978 1 4456 5448 5 (print)
ISBN 978 1 4456 5449 2 (ebook)

British Library Cataloguing in
Publication Data.
A catalogue record for this book is
available from the British Library.

Typesetting by Amberley Publishing.
Printed in Great Britain.

INTRODUCTION

The Parish Church of St John the Baptist, with its proud tower and profusion of large windows, has changed little in the centuries since its completion around 1405. A Yeovilian, should he or she jump on a time machine and return seven hundred years later, would almost certainly recognise the Church, even if everything else appeared alien. St John's was described by the eminent Victorian English historian and architectural artist, Edward Augustus Freeman, (1823–1892) 'as one grand and harmonious whole ... as perfect in its own way as truly the work of real design and artistic genius as Cologne, or Winchester, or St Ouen's'.

Yeovil has been, and continues to be, a town of change even though its main street, Middle Street, still follows the line of the ancient thoroughfare, and the dimensions of the Borough are almost certainly those of the medieval town market place.

The photographs in the History Tour provide a glimpse of the town during the first half of the twentieth century but above many of the modern shop fronts of the buildings in the main streets that earlier Yeovil remains.

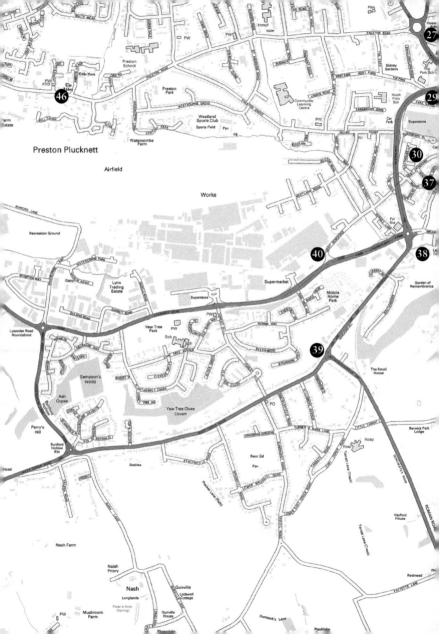

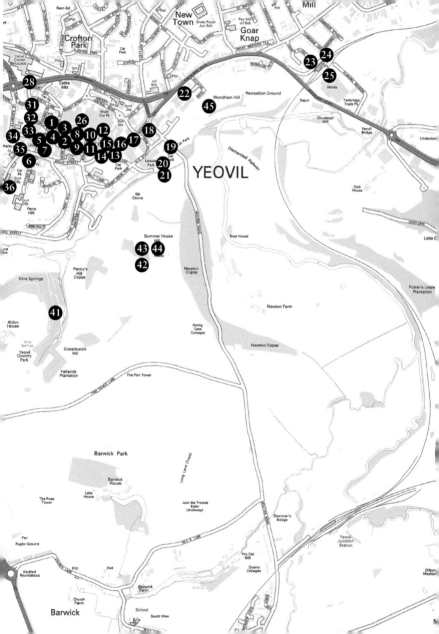

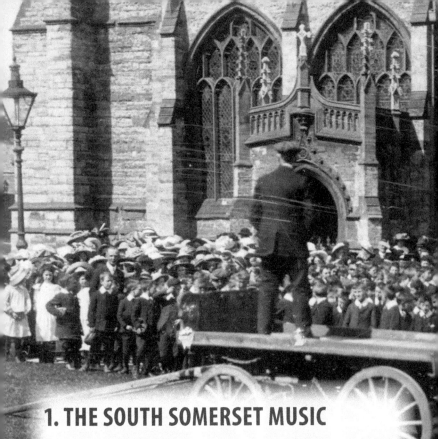

1. THE SOUTH SOMERSET MUSIC COMPETITION

This postcard was sent in May 1912 and shows some of the young people participating in the South Somerset Music Competition in St John's Churchyard on 23–25 April 1912. The 1912 competition of vocal and orchestral music was just one of the many and varied events held over the years in the churchyard, which is now delightfully planted with flowers by South Somerset District Council.

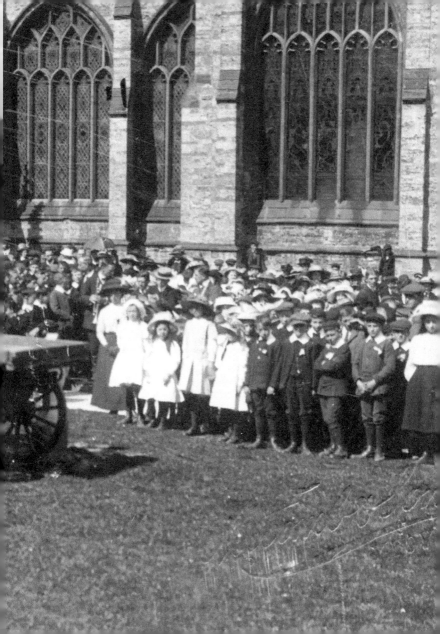

2. THE BOROUGH LOOKING EAST

The Borough is the ancient heart of Yeovil going back to the town's Saxon beginnings over a thousand years ago and yet it actually forms part of the postal address of the High Street. The postcard from the 1920s this scene has changed with the bustle of motor vehicles and cyclists and by the impressive Midland Bank (now HSBC), built in 1914. The Medical Hall, subsequently Boots, destroyed by a German bomb on Good Friday night 1941, was rebuilt in 1956, and is now a Burger King.

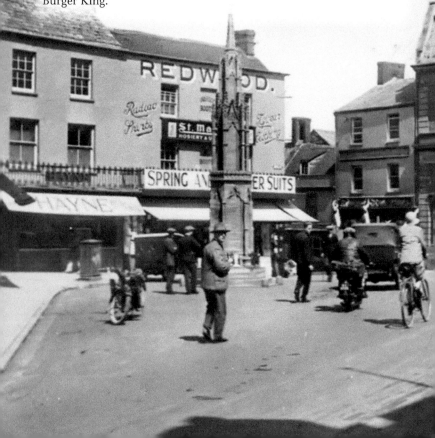

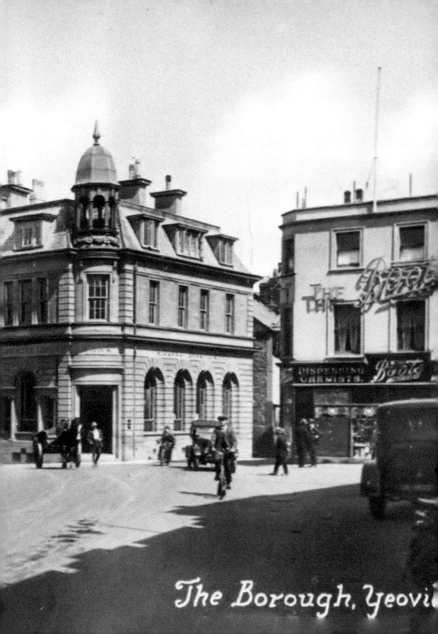

The Borough, Yeovil

3. THE BOROUGH LOOKING WEST

Although the postcards are twenty years apart, from 1905 and 1925 there are two notable differences. In 1905, the large building on the left is the Town Hall (built 1849) and by 1925 (inset) it is crowned by an impressive clock tower, the gift of Thomas William Dampier and his sister to commemorate the coronation of King George V in 1911. The war memorial is now a prominent feature.

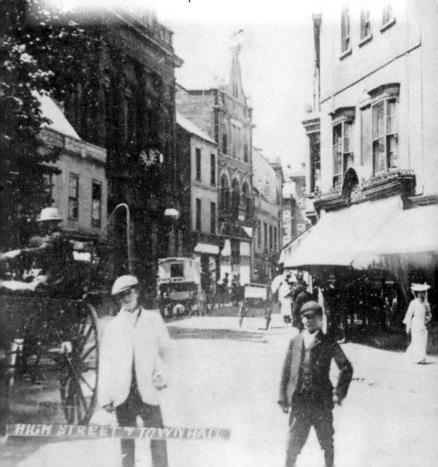

HIGH STREET & TOWN HALL

4. HIGH STREET LOOKING EAST

Two pictures of High Street from 1912 and 1935 (inset). The prominent clock tower on the Town Hall (centre) caught fire on 22 September 1935 and the resulting blaze destroyed the building. The large Sugg gas lamp, standing at the entrance to High Street in 1912, was removed in 1928, and in its place in 1935 an RAC patrolman directs traffic from a white circle painted on the main A30 London Road. In 2000 the Millennium Clock, designed by local historian, the late Leslie Brooke, was erected on site of the gas lamp.

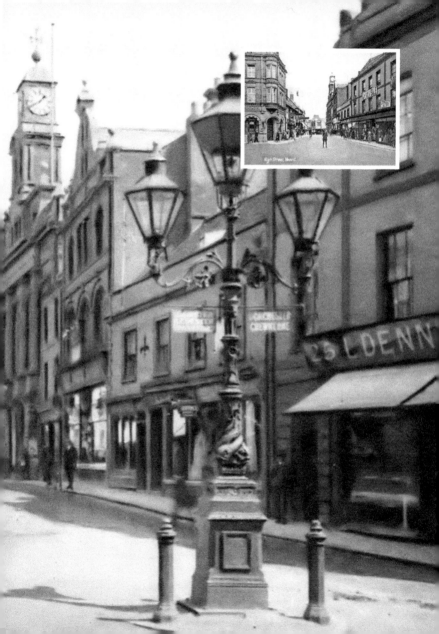

5. HIGH STREET LOOKING WEST

This postcard was posted in 1907 and a closer look reveals a glimpse of the future under the clock where a sign advertises a garage and motor spirit. The inset photograph can be dated by the advertisement of Gamis's 'Household Sale' commencing 20 February 1931 and shows an almost deserted High Street. Beyond Barclay's bank is the Town Hall and then Clement's stores with its prominent roof line. The site of the Town Hall now accommodates the Borough Arcade, and Clement's shop was demolished in the 1960s and is now the site of the Argos store. Gamis' premises were rebuilt in 1933.

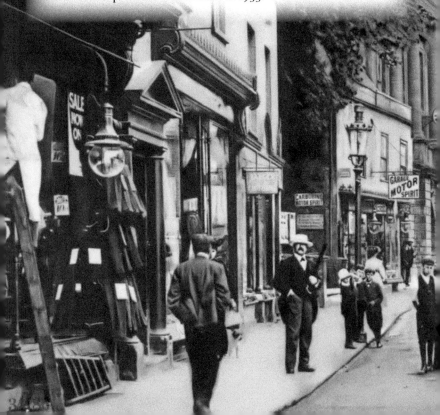

Street, Yeovil.

6. SOUTH STREET FIRE

On 23 February 1906 a fire started in the back cheese store of Clement's grocery shop, on the High Street. Spreading rapidly at roof-level, it threatened the Three Choughs Hotel, on Hendford, in addition to the two ancient thatched cottages, on South Street (shown here). The Yeovil Volunteer Fire Brigade (formed 1861), commanded by Captain Edmund Damon, rushed to the scene, but unfortunately could not save the homes of the Parsons and Field families. Ironically, in 1913, the Fire Brigade moved in next door, when the old Cheese Market was converted into the town's first proper Fire Station.

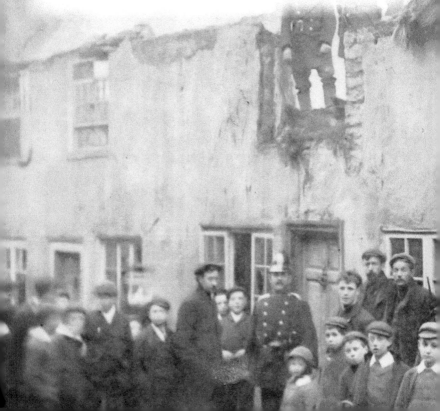

RUINS FROM FIRE
AT YEOVIL 23·2·0

Photo by
W. ROS
& Co

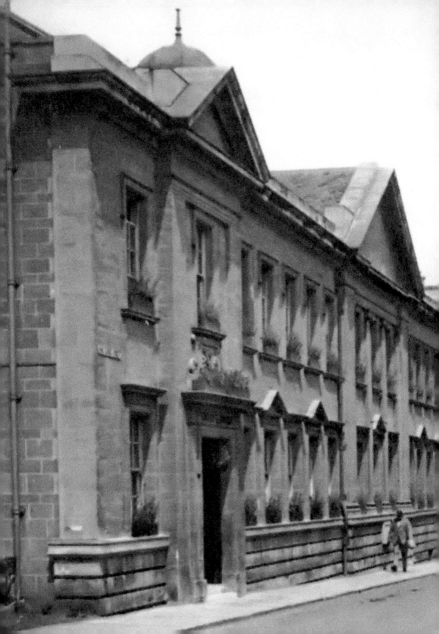

7. KING GEORGE STREET, c. 1935

King George Street from the mid-1930s, shows on the left the Yeovil Borough Council's 'New English Renaissance' municipal offices, library and museum opened in 1928, and opposite, the General Post Office built in 1932. Now traffic-free, King George Street with its trees and seats, is a pleasant part of central Yeovil.

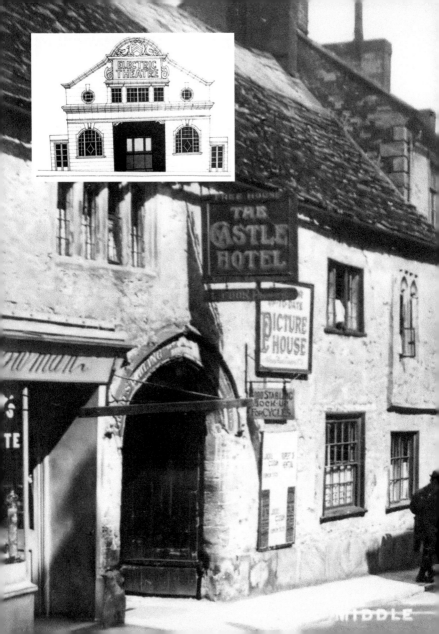

ELECTRIC THEATRE

THREE TUNS
THE CASTLE HOTEL

UP TO DATE
PICTURE
HOUSE

AND STABLING
LOCK-UP
For CYCLES

MIDDLE

8. MIDDLE STREET LOOKING EAST, *c.* 1910

In 1919 it was proposed to build the 'Electric Theatre' shown in the inset, on the site of the ancient Castle Hotel. The plans never materialised, but the hotel succumbed to the Montague Burton chain of men's outfitters whose shop was destroyed by a German bomb in October 1940.

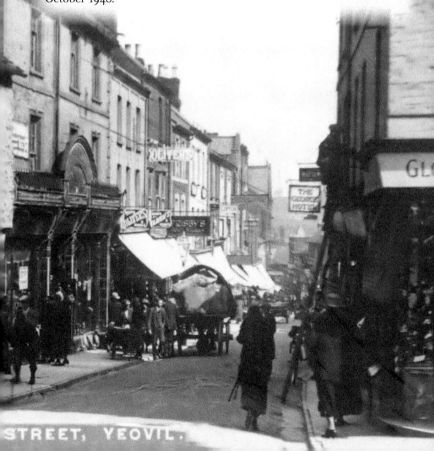

STREET, YEOVIL.

9. MIDDLE STREET LOOKING WEST, c. 1925

In this photograph from the 1920s, Messrs W. H. Smith's book shop is featured prominently on the right, and at the entrance was a large open counter for the sale of newspapers and magazines. In 1932, the General Post Office, just off to the left, moved to King George Street and Marks & Spencer took over the premises. In the 1970s, a form of retail 'musical chairs' took place when Messrs Smith moved into Marks & Spencer's premises and Marks & Spencer moved to a new store across the road!

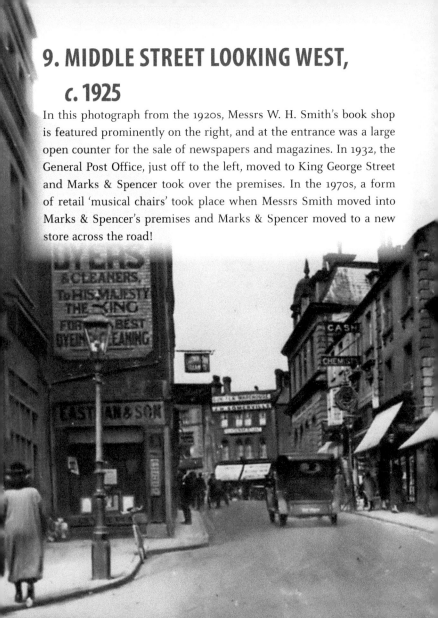

10. MIDDLE STREET – THE GEORGE INN LOOKING EAST, *c.* 1925

The photograph from the 1920s shows The George Inn as many people remember it, and indicates how narrow this part of Middle Street was at the time. The increase in traffic during the nineteenth and early twentieth centuries had resulted in Middle Street being widened but a bottle neck remained outside The George. In 1962, following a public inquiry, the owners received permission to redevelop the site with shops and provide land for road widening. The George was demolished but within less than ten years, this part of Middle Street was pedestrianised.

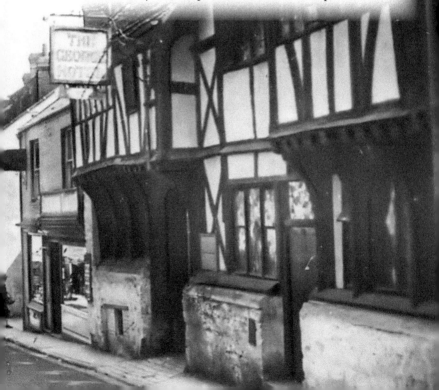

11. MIDDLE STREET – THE GEORGE INN LOOKING WEST, *c.* 1900

This postcard from a century ago once again emphasises how narrow Middle Street was outside The George Inn. It also shows the multitude of hanging signs and shop blinds which were such a feature of the time. Note the rather drab façade of The George.

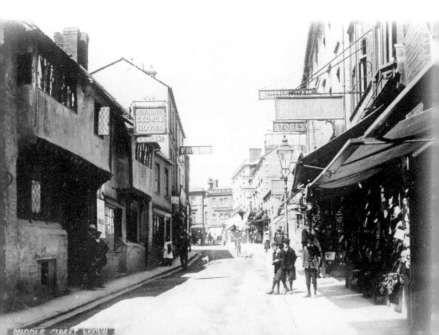

12. MIDDLE STREET – CURRY'S LOOKING WEST, 1930

This photograph of Middle Street gives a fairly good impression of how four motor vehicles and a few cyclists could make the street look somewhat congested.

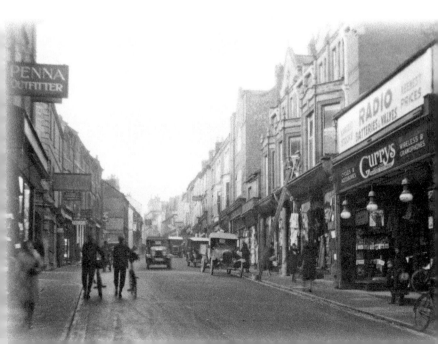

13. THE TRIANGLE LOOKING EAST, *c.* 1896 AND *c.* 1906

The photograph taken *c.* 1896, shows how this part of Middle Street was beginning to change. On the left is a cottage still with a small front garden, but further down, ground floors have been converted to shops and on the right is Jesty's new furniture emporium.

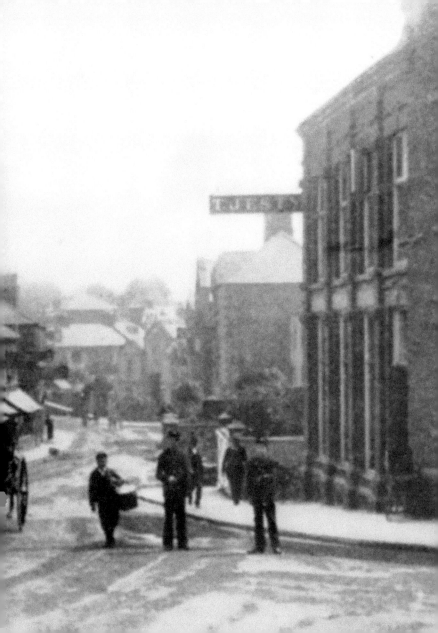

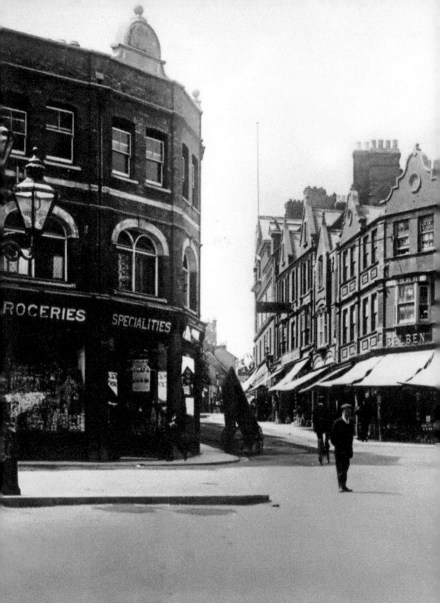

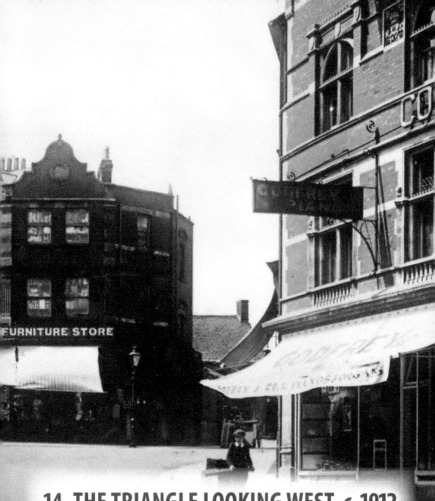

FURNITURE STORE

14. THE TRIANGLE LOOKING WEST, *c.* 1912

The picture, shows three well-known Yeovil landmarks of the last century – the Yeovil Co-operative Central Stores (built 1910), Belben's Bazaar and furniture store in the centre, and the Coronation Hotel.

15. THE PALACE CINEMA, *c.* 1913

'A WARD'S PALACE' opened for film shows and stage performances at the Triangle on 10 February 1913. Following its sale in 1929 to the Gaumont-British Picture Corporation, the Palace was demolished and a new Gaumont cinema, declared 'a triumph of modern art', opened on 15 December 1934. Although the Gaumont closed for films in 1972, the old cinema remains a well-known Yeovil landmark.

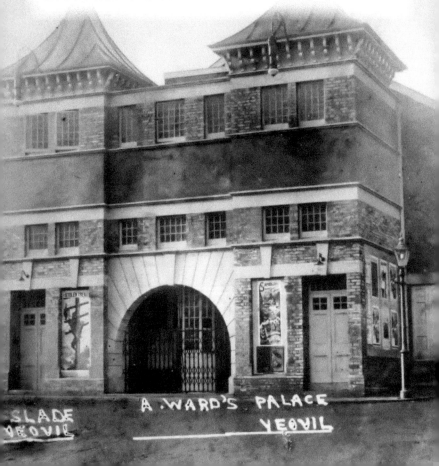

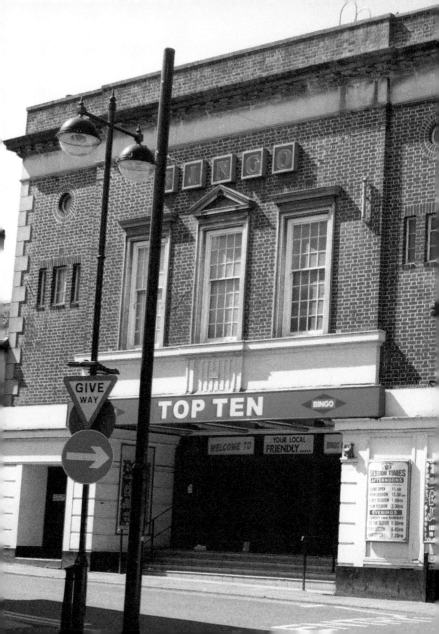

Middle Street, Yeovil

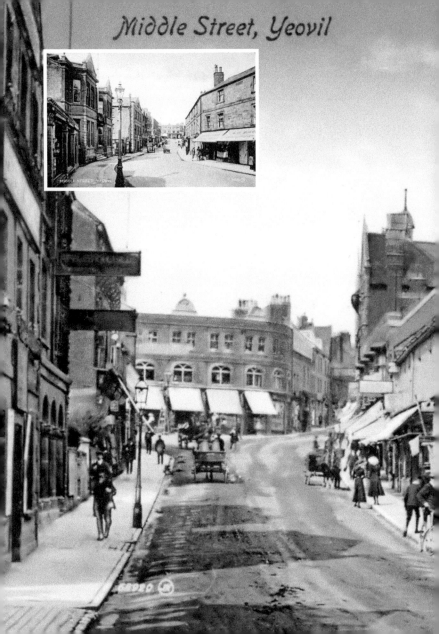

16. LOWER MIDDLE STREET LOOKING WEST, *c.* 1912 AND *c.* 1925

In the view from 1912, the well-presented terrace of Hamstone properties on the right appear to have been turned into small shops on their ground floors probably reflecting the growth of Middle Street eastwards during the second half of the nineteenth century. In the later view (inset), on the immediate left is a glimpse of Yeovil Gas Works' showrooms, followed by the Liberal Club (built in 1895) and the neighbouring substantial building housed the offices and printing works of the *Western Chronicle* weekly newspaper, published from 1886 to 1931.

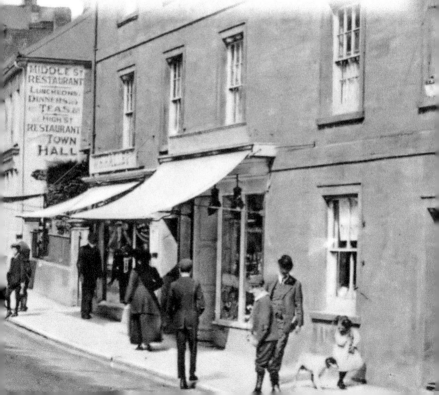

17. LOWER MIDDLE STREET LOOKING TOWARDS SHERBORNE ROAD, *c.* 1930 AND *c.* 1955 (INSET)

Following the opening of the Town Station in 1861, there was rapid growth of commercial and residential development eastwards along London Road, and the road was renamed Middle Street up to the junction with Wyndham Street and Newton Road. The majority of the premises shown in the postcard from 1930 were built within a few years of 1861. The large building on the corner of Middle Street and Station Road was the Fernleigh Commercial Hotel, but in the postcard from the mid-1950s, the offices of the Southern National Omnibus Company have become established in the premises.

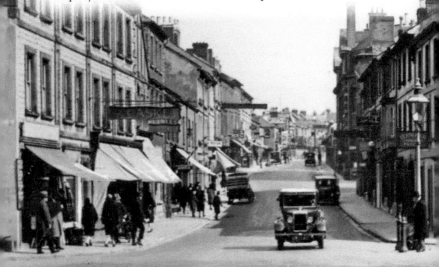

Middle Street, Yeovil

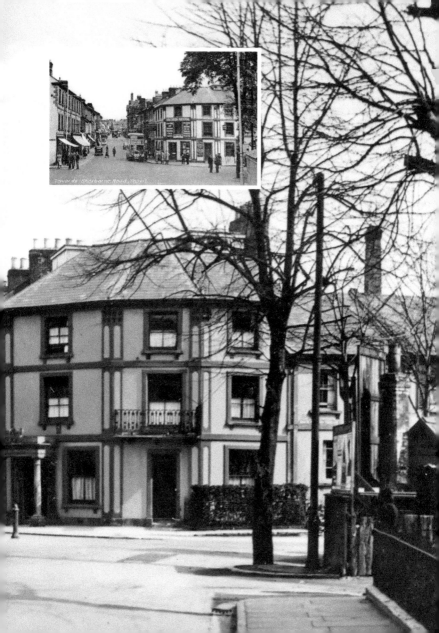

Towards Sherborne Road, Yeovil

18. STATION ROAD, c. 1896 AND 1934

The photograph of Station Road dates from about 1896, and the road leads past the rather fine buildings of South Western Terrace on the left down to the Town Station. However, the view from South Western Terrace was somewhat spoilt by the large coal yard on the opposite side of the road. In the photograph from 1934, four horse carts stand on the station forecourt about to transport toys to Gamis's Stores in High Street, having just collected the packing cases from the goods yard. The Town Station closed in 1967 and in 1971, was purchased by Yeovil Borough Council which enabled the authority (and its successor South Somerset District Council) to redevelop the area.

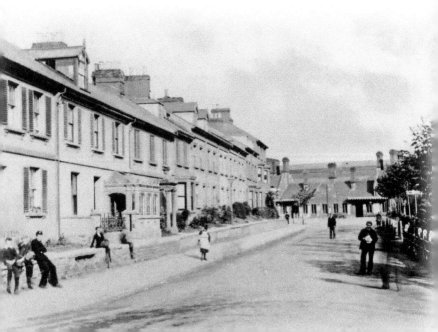

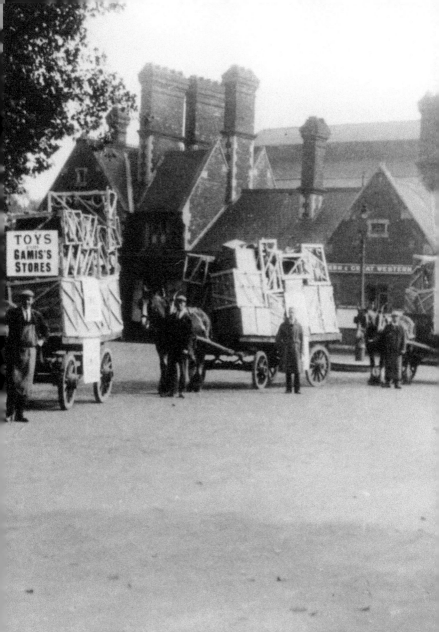

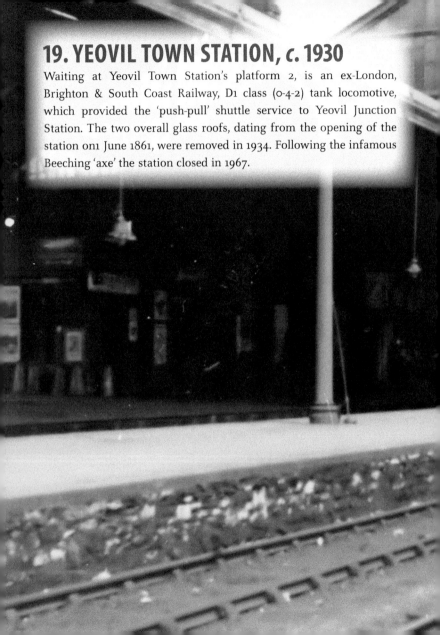

19. YEOVIL TOWN STATION, *c.* 1930

Waiting at Yeovil Town Station's platform 2, is an ex-London, Brighton & South Coast Railway, D1 class (0-4-2) tank locomotive, which provided the 'push-pull' shuttle service to Yeovil Junction Station. The two overall glass roofs, dating from the opening of the station on 1 June 1861, were removed in 1934. Following the infamous Beeching 'axe' the station closed in 1967.

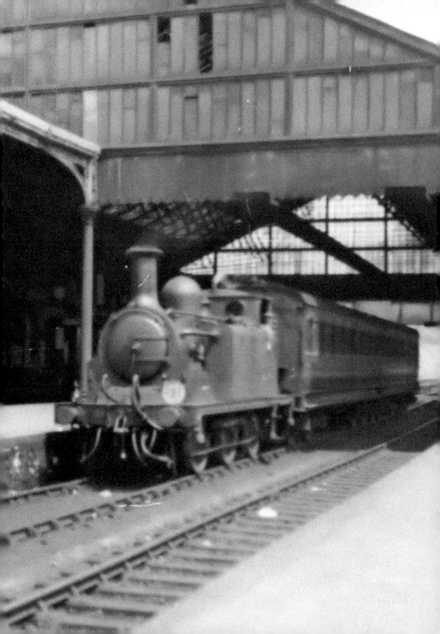

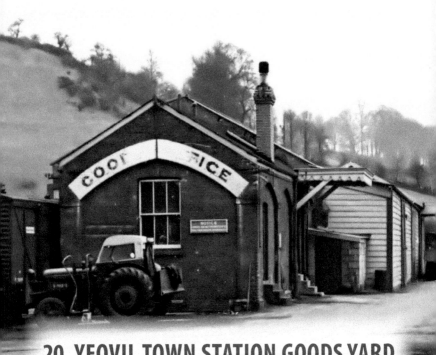

20. YEOVIL TOWN STATION GOODS YARD

The estate car shown prominently in this photograph, taken about forty years ago, stands at the entrance to the Yeovil Town Station Goods Yard. On the right can be seen the premises of E. J. Farr's scrap metal business, and just behind there is a brief glimpse of Pulman's glove factory, now known as Foundry House. Following the closure of the Town Station, the goods yard formed part of a public car park, and in 2002, Yeo Leisure Park, opened on the site providing a range of entertainments and restaurants.

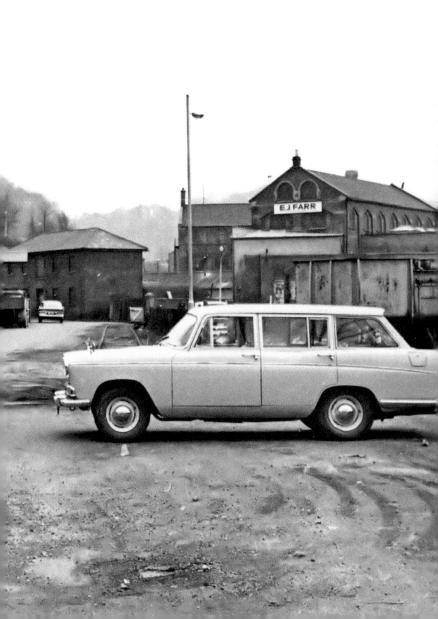

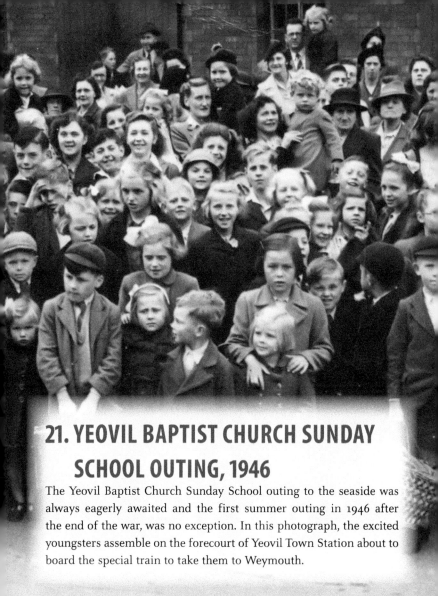

21. YEOVIL BAPTIST CHURCH SUNDAY SCHOOL OUTING, 1946

The Yeovil Baptist Church Sunday School outing to the seaside was always eagerly awaited and the first summer outing in 1946 after the end of the war, was no exception. In this photograph, the excited youngsters assemble on the forecourt of Yeovil Town Station about to board the special train to take them to Weymouth.

22. SHERBORNE ROAD/RECKLEFORD JUNCTION, *c.* 1898

There is not a vehicle in sight in the old photograph taken around 1898 at the junction of Sherborne Road and Reckleford, and is in complete contrast with the present heavy traffic.

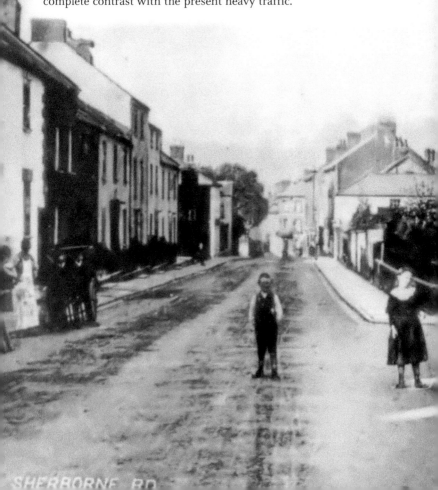

SHERBORNE RD

23. YEOVIL PEN MILL STATION, 16 FEBRUARY 1964

The 'Quantock Flyer' rail tour, organised by the Locomotive Club of Great Britain, was double-headed by locomotives no. 4593 (2-6-2) prairie tank and no. 9663 (0-6-0) pannier tank. It is seen here about to depart from Pen Mill Station for Taunton, via Yeovil Town and Durston. The station was opened by the Wilts, Somerset & Weymouth Railway (GWR) on 1 September 1856 and retains many of its original features. Today it is a passing loop on the single-line section between Castle Cary and Maiden Newton.

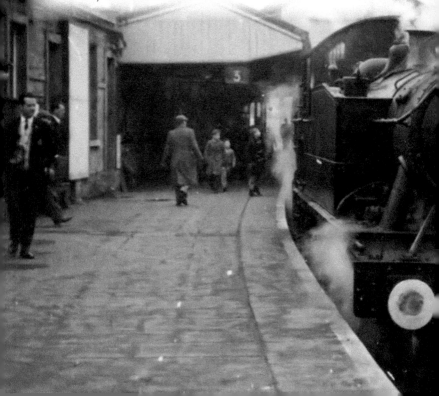

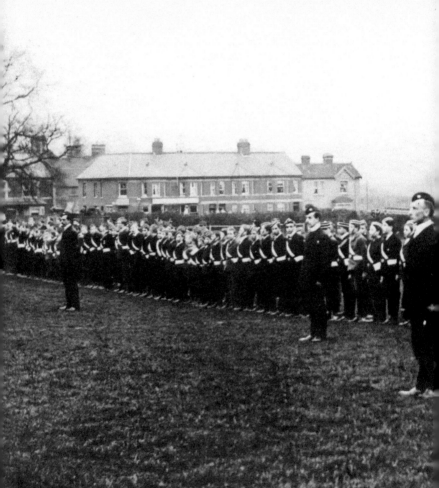

INSPECTION OF BOYS BRIGADE AT YEOVIL
BY MAJOR SMITH 5

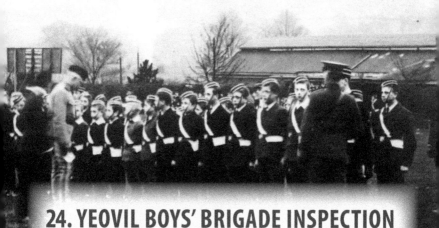

24. YEOVIL BOYS' BRIGADE INSPECTION AT PEN MILL, 1905

In this 1905 photograph, Major W. A. Smith, the founder of the Boys' Brigade, inspects the Yeovil Battalion on the Pen Mill Athletic Ground, the home of the Yeovil Casuals Football Club, and next to the Pen Mill Hotel. The roof of Yeovil Pen Mill Station can be seen at the right of the photograph, and a glimpse of goal posts on the left. The use of the ground ceased in the 1920s, when football transferred to Huish, and remained as open ground until the present residential development was carried within the past few years.

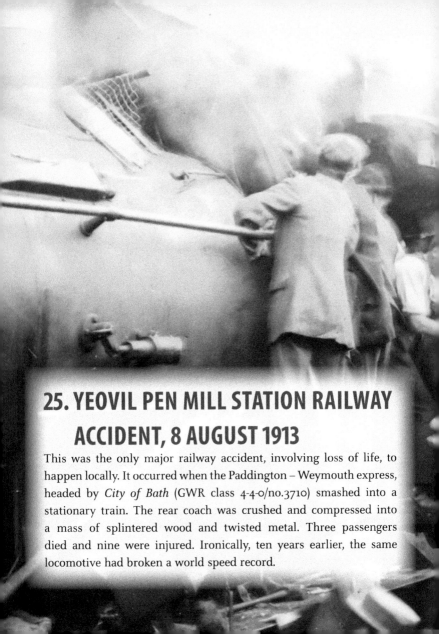

25. YEOVIL PEN MILL STATION RAILWAY ACCIDENT, 8 AUGUST 1913

This was the only major railway accident, involving loss of life, to happen locally. It occurred when the Paddington – Weymouth express, headed by *City of Bath* (GWR class 4-4-0/no.3710) smashed into a stationary train. The rear coach was crushed and compressed into a mass of splintered wood and twisted metal. Three passengers died and nine were injured. Ironically, ten years earlier, the same locomotive had broken a world speed record.

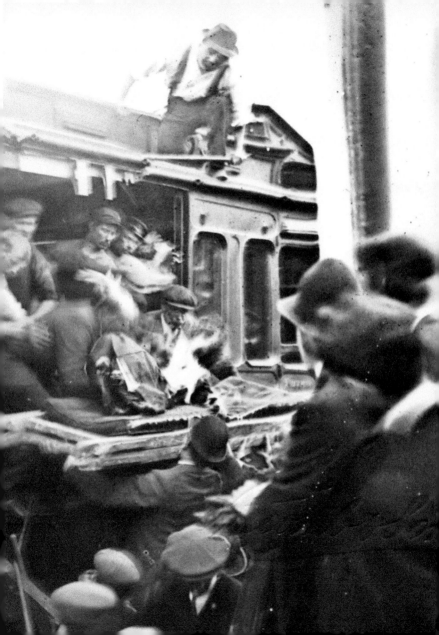

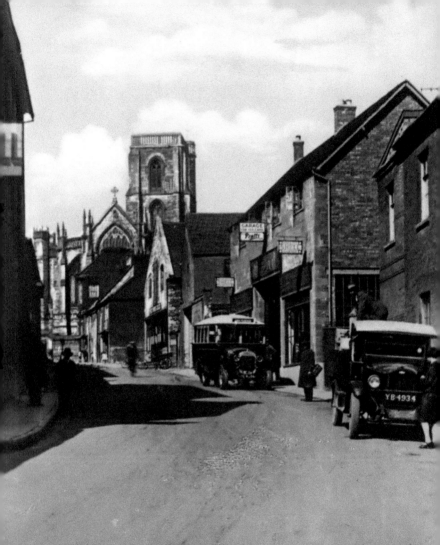

Vicarage Street Yeovil

26. VICARAGE STREET c. 1934

The postcard shows St John's Church looking down upon Vicarage Street, one of Yeovil's ancient thoroughfares, and apart from the motor vehicles, a scene probably little changed for a century. In April 1983, Vicarage Street was closed to traffic and work began on the Quedam Shopping Centre. Vicarage Walk, the pedestrian thoroughfare through the Quedam, follows the line of the old Vicarage Street and its ancient predecessor, Quidam or Quidham – after which the shopping centre is named. In his book *Yeovil History in Street Names* (1988), local historian, the late Leslie Brooke, suggests that the Latin word 'Quedam' meaning 'a property in a certain place' may have been the origin of the name. The image below shows the area in 1984.

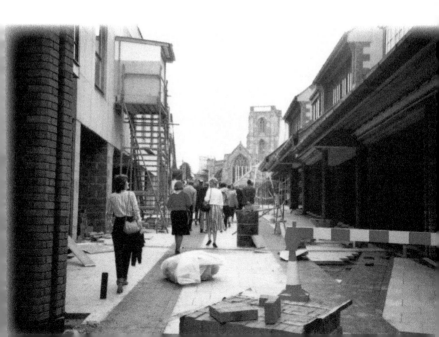

27. KINGSTON, c. 1900

Kingston has changed since this postcard was published a century ago! Although the terrace of houses on the right and the large house beyond remain, all the houses on the left were demolished over forty years ago for the construction of the Kingston dual carriageway and the new Yeovil District Hospital which opened in October 1973.

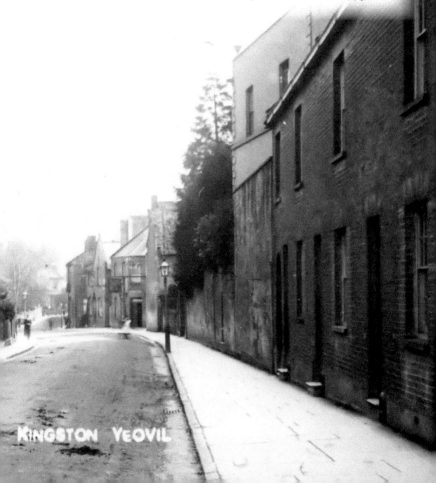

KINGSTON YEOVIL

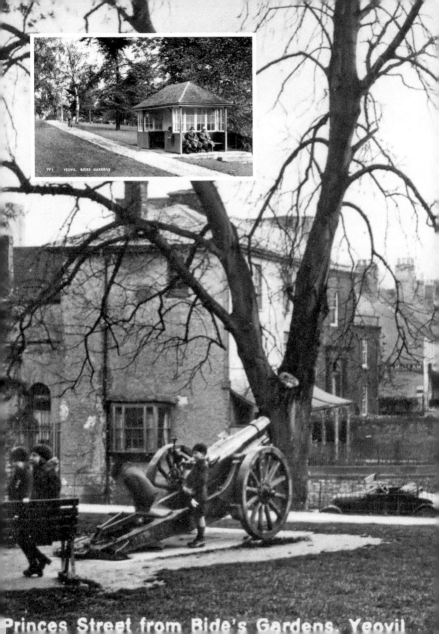

Princes Street from Bide's Gardens. Yeovil

28. BIDE'S GARDENS, RECKLEFORD,
c. 1930 AND c. 1950 (INSET)

These postcards show the sylvan tranquillity that remarkably used to exist, close to the town centre, prior to the construction of the Reckleford dual-carriageway in 1966. Bide's Gardens had been created by the Yeovil Borough Council in 1921, as a direct result of widening Court Ash, between Higher Kingston and Kingston. The cost of the widening scheme was partly financed by central government, to relieve local unemployment. The name 'Bide's Gardens' honours the original donor of the land – the Dampier-Bide family of Kingston Manor House. The field gun 'gate-guardian' was a relic from the First World War and was no doubt used as 'salvage', to aid the war effort in the Second World War. Remnants of Bide's Gardens can still be traced today, in the grass verge and trees between between Court Ash and Reckleford, and in the greensward outside Yeovil District Hospital.

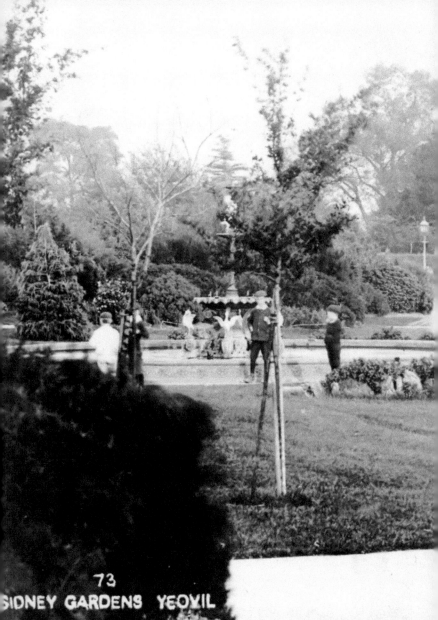

73

SIDNEY GARDENS YEOVIL

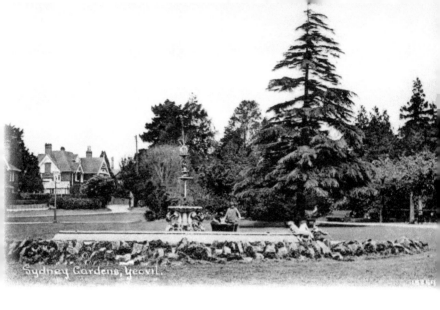

Sydney Gardens, Yeovil.

29. SIDNEY GARDENS, THE PARK, *c.* 1906 AND *c.* 1920

At a special meeting of the Yeovil Borough Council in June 1897, it was resolved to accept the generous offer of the Mayor, Sidney Watts, to donate land at Ram Park (now The Park), as a pleasure garden. Though named 'Sidney Gardens' (and not 'Sydney Gardens' as in the 1920s postcard, above), it was created to commemorate Queen Victoria's Diamond Jubilee. Laid out in the style of a London park, complete with rustic bandstand, it was formally opened on 23 June 1898. The following year an ornamental fountain was unveiled to celebrate the Queen's eightieth birthday. Though the bandstand has long gone, the fountain remains amidst the still lush, sylvan setting.

30. PRINCES STREET LOOKING NORTH, *c.* 1920

Princes Street has changed very little in the eighty or so years since the photograph was taken. The corner of Princes Street and Westminster Street, was known for many years as 'Genge's Corner' after Alfred Genge who owned a large fancy draper's shop on the corner.

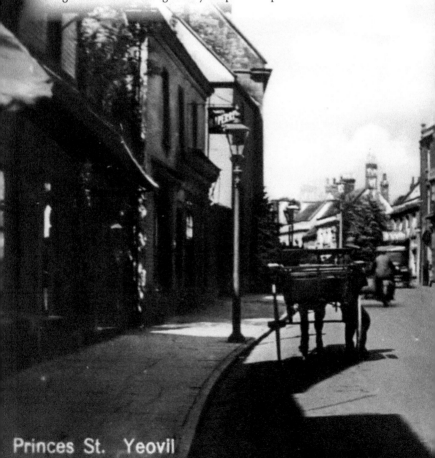

Princes St. Yeovil

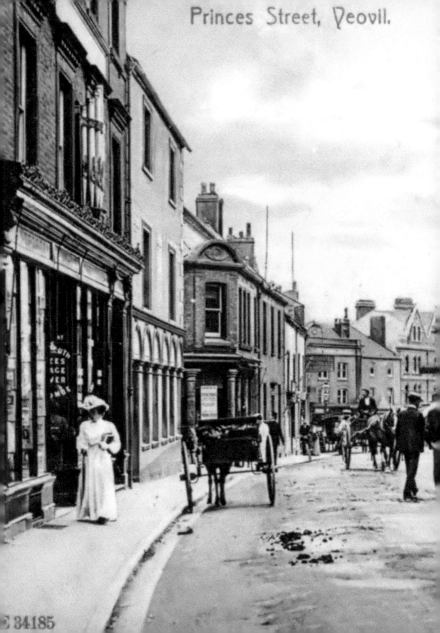

Princes Street, Yeovil.

E 34185

31. PRINCES STREET LOOKING SOUTH, c. 1900

Once again this view of Princes Street has changed little during the intervening century. On the left of this postcard, the elegant lady dressed in white, passes 'Handel House' the premises of E. Price & Sons, retailers of pianos and organs, note the organ pipes above the shop front, and on the right with the two large gas lamps in the forecourt, is Albion House, Whitby's bookshop, and stationers (established 1844).

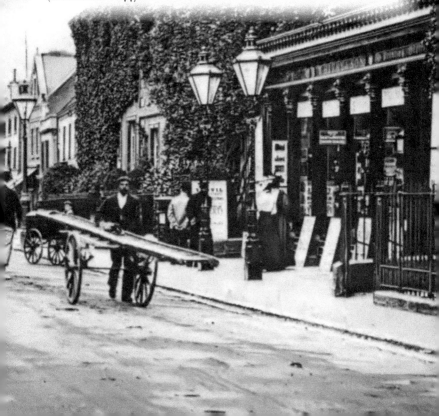

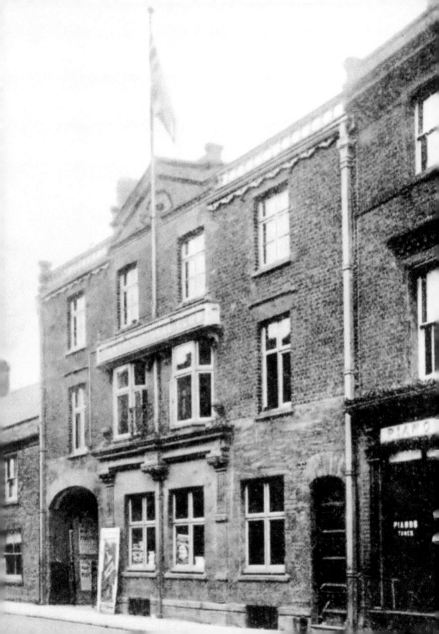

32. THE ASSEMBLY ROOMS, c. 1900

Built in 1889 as part of the Constitutional Club, the Princes Street Assembly Rooms became a popular venue for a wide range of entertainments. There were concerts, dances, amateur operas, pantomimes and theatrical productions, including a resident repertory company, the ROC Players, during the 1950s. By the time the Johnson Hall/Octagon Theatre opened in 1974, the Assembly Rooms had lost much of its popularity and was closed when the Constitutional Club relocated to the old Duke of York on Kingston. The building is now used for commercial and residential purposes.

33. THE CENTRAL CINEMA, *c.* 1960

The Persian-style Central Cinema, was opened on Church Street in January 1932, and replaced the original Central Hall Picture Palace which had burnt down on 24 May 1930. Although the Central operated as an independent cinema, and often showed films the major cinema chains did not, the decline in audiences during the 1960s, forced its closure in May 1964. Following some years as a Bingo and Social Club, the Central finally closed in 1979, was demolished nine years later, and the new building on the site is occupied by a firm of solicitors.

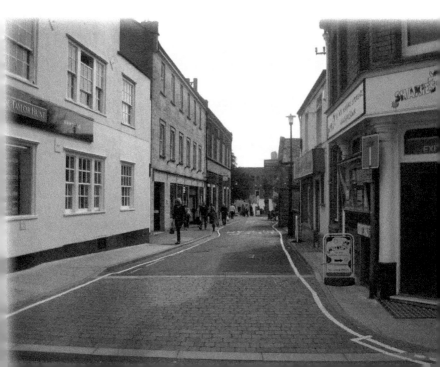

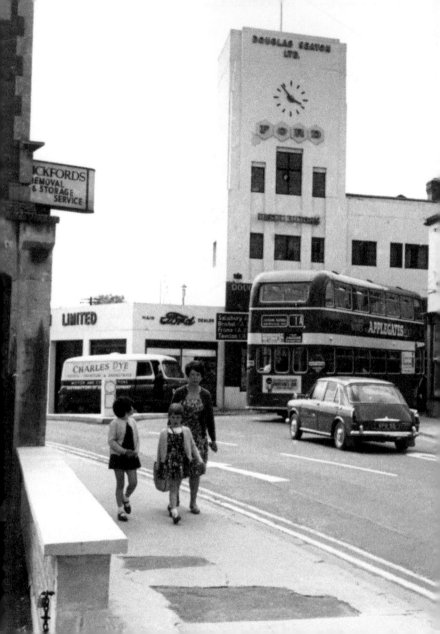

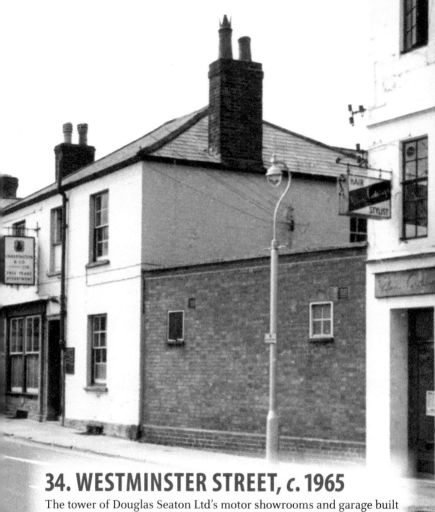

34. WESTMINSTER STREET, c. 1965

The tower of Douglas Seaton Ltd's motor showrooms and garage built in 1931, dominates the junction of Westminster Street with Huish and Clarence Street. In 1990, the familiar land mark was demolished to make way for Tesco's store and large car park.

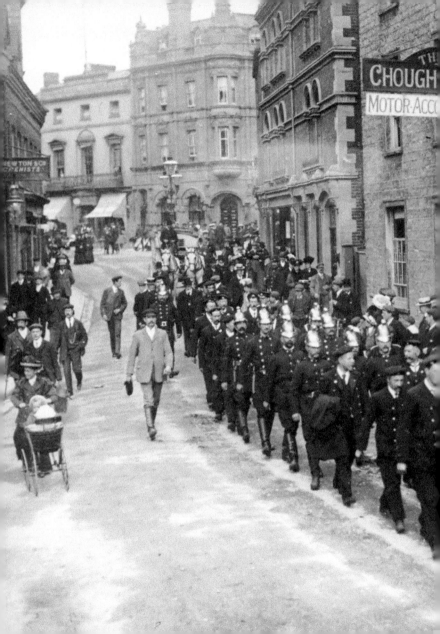

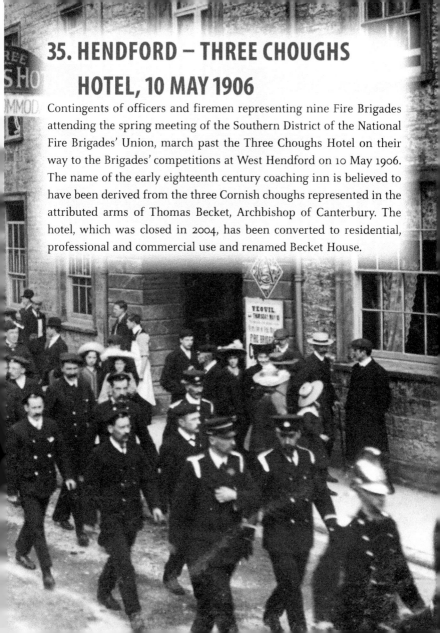

35. HENDFORD – THREE CHOUGHS HOTEL, 10 MAY 1906

Contingents of officers and firemen representing nine Fire Brigades attending the spring meeting of the Southern District of the National Fire Brigades' Union, march past the Three Choughs Hotel on their way to the Brigades' competitions at West Hendford on 10 May 1906. The name of the early eighteenth century coaching inn is believed to have been derived from the three Cornish choughs represented in the attributed arms of Thomas Becket, Archbishop of Canterbury. The hotel, which was closed in 2004, has been converted to residential, professional and commercial use and renamed Becket House.

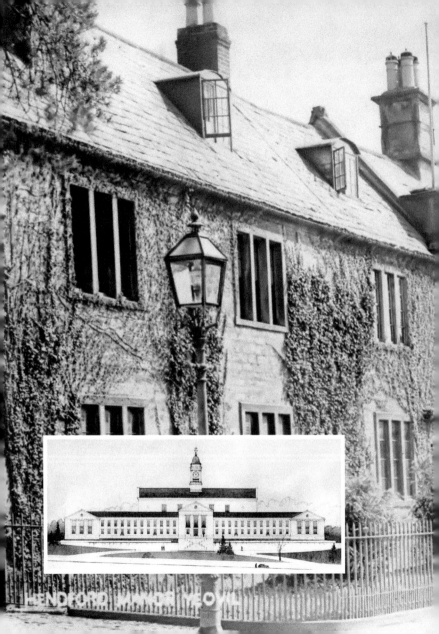

HENDFORD MANOR YEOVIL

36. HENDFORD – HENDFORD MANOR HOUSE, *c.* 1909 AND *c.* 1938 (INSET)

Hendford Manor House, shown in this postcard from a century ago, was built by James Hooper in 1750. Following the destruction of the Town Hall by fire, the Borough Council bought the house and grounds in 1936 for the site of a new town hall. Plans for the new building, (shown in the inset), were approved but the outbreak of war in September 1939 stopped the project and it was never revived. The Manor House is now used for offices.

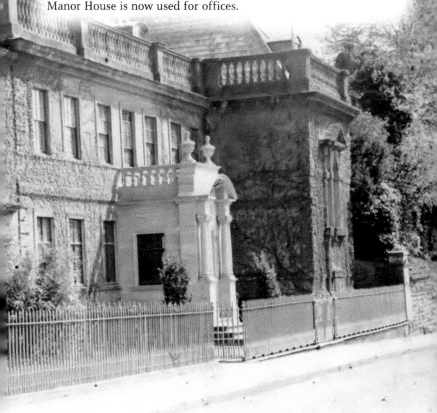

37. HENDFORD MANOR GARDEN c. 1900

The garden of Hendford Manor House, shown in this postcard from around 1900, is now occupied by the Octagon Theatre, Yeovil's premier venue for live concerts and theatre. Opened in 1974 by the Yeovil (now renamed South Somerset) District Council as the multi-purpose Johnson Hall, it became apparent within a decade that the building was more suitable for theatre and from a local press competition, the name 'Octagon' was chosen in 1984. From successive improvements during the past twenty-five years, the Octagon has emerged as a major regional theatre.

44781. YEOV
HENDFOR

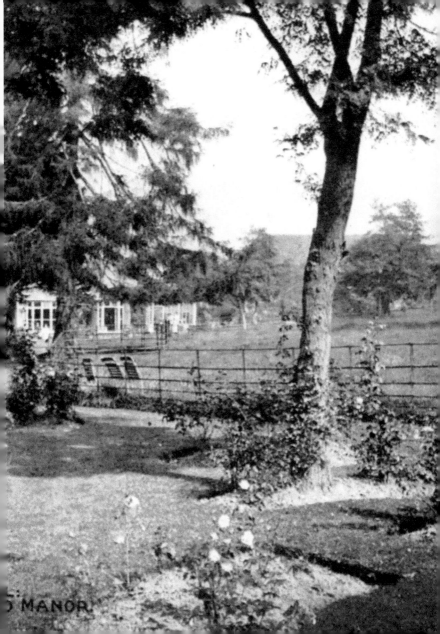

MANOR

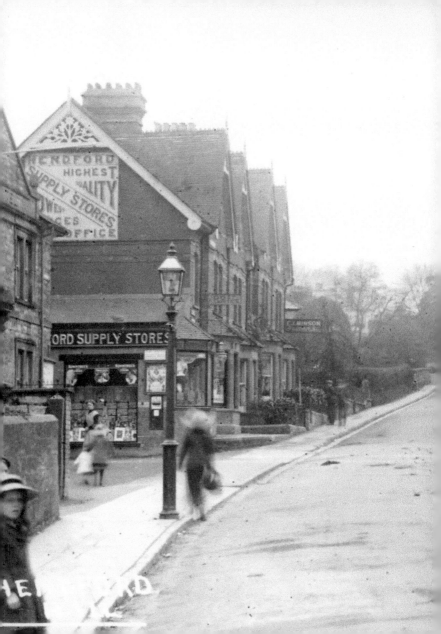

38. HENDFORD HILL LOOKING SOUTH, c. 1915

On 6 May 1915, Harry sent the postcard of Hendford Hill to Aunt F. in Johnstown, New York State, and today, Harry could still recognise the Hill. On the right, the two buildings flank the entrance to Hendford railway goods yard, Bradford and Sons' offices are clearly marked and the other building belongs to the Somerset Trading Company – both builders' and general merchants. The goods yard closed in the 1960s, and the two buildings were demolished for road widening.

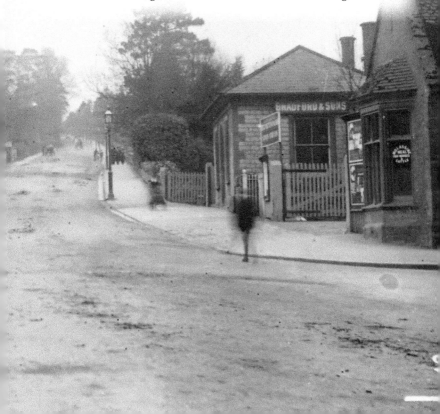

39. HENDFORD HILL LOOKING NORTH,
c. 1910

In this century-old postcard, the Wesleyan Sunday School scholars and their banner, have almost reached the top of Hendford Hill and the field where they will have their summer picnic. Behind the column, a horse bus labours up the hill and in the distance with a cloud of dust is the future – a motor car.

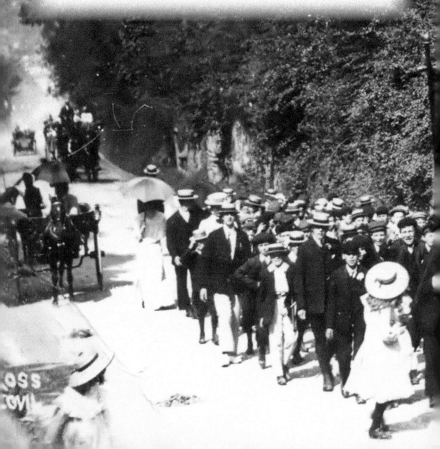

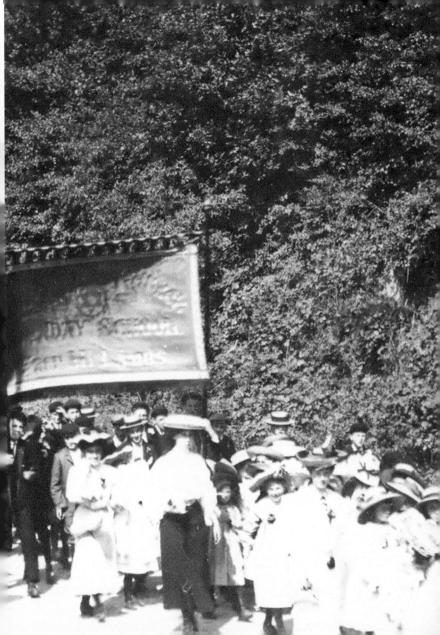

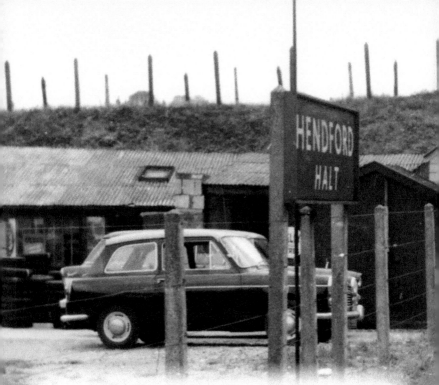

40. HENDFORD HALT, *c.* 1963

Hendford Halt is often confused with Hendford Station. The latter was Yeovil's first railway station, connecting the town with Taunton – opened on 1 October 1853. Built by the Bristol & Exeter Railway, it was situated just beyond the Yew Tree Lane over-bridge. However, its life as a passenger station was short-lived, being superseded by the more centrally-located, Yeovil Town Station (1861). The Halt itself, opened on 2 May 1932, was built largely for the convenience of the nearby Westland Aircraft factory. Closed in 1964, the track-bed has become a pleasant foot and cycle path through Yeovil Country Park.

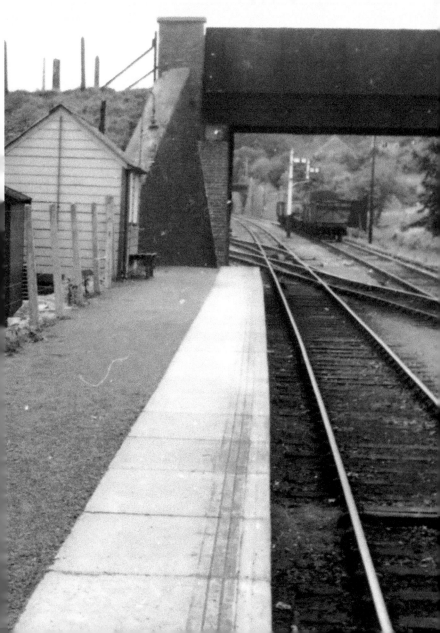

41. NINE SPRINGS, c. 1939

Nine Springs originated in the 1830s as the private pleasure grounds of the Batten family of Aldon House. It was designed using natural springs and features, to provide ponds, waterfalls and paths in a woodland landscape of specimen trees. The Yeovil Borough Council leased the land for public access in 1932, and admission was by ticket only, obtainable from the Town Clerk – who just happened to be Colonel Henry Copeland Cary Batten, of Aldon. By the mid-1960s the condition of Nine Springs had deteriorated to such an extent, that clear felling and replanting of the slopes was necessary. In 1979 Yeovil (now South Somerset) District Council bought the site and further extensive restoration and improvements have been carried out since – it now forming part of Yeovil Country Park. The much-photographed, thatched cottage was at one time used to serve light refreshments. Sadly, it was neglected, fell into disrepair and was eventually demolished many years ago.

NINE SPRINGS, YEOVIL.

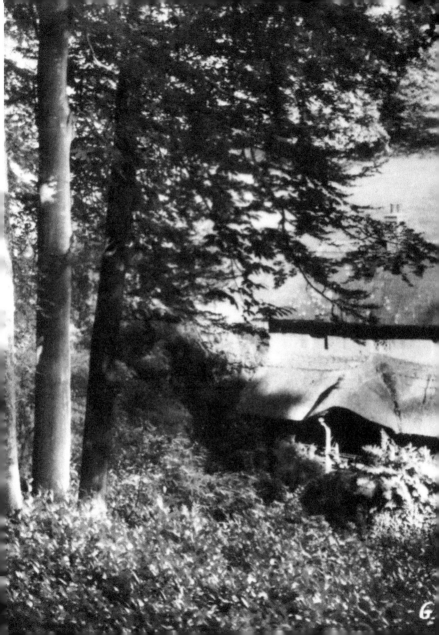

42. VIEW TOWARDS PENN HILL FROM SUMMERHOUSE HILL, *c.* 1920

Penn Hill was much more heavily wooded in the early years of the twentieth-century than it is today. The long row of terraced houses (Park Street) bisects the image, with the Victoria Bridge crossing over the Yeovil Town –Taunton railway line (opened 1861) prominent in the foreground. Between the two, are Town Mill and several leather dressing yards – all long since gone.

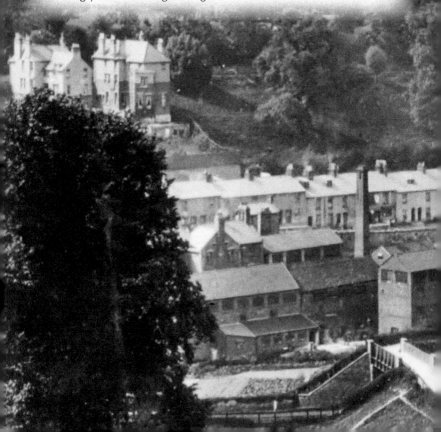

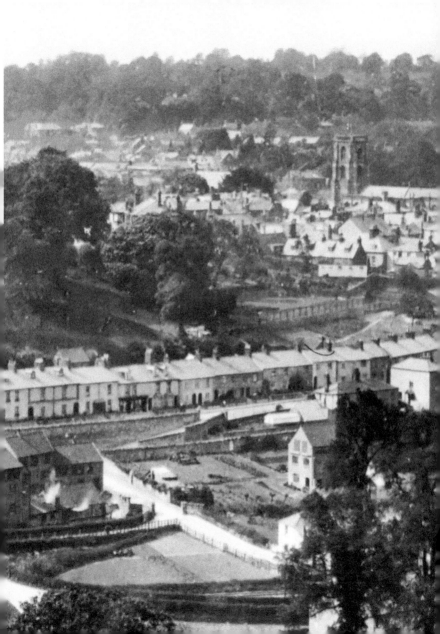

43. VIEW TOWARDS YEOVIL GAS WORKS FROM SUMMERHOUSE HILL, *c.* 1900

The rather intrusive gasometer, boldly marks the location of Yeovil's Gas Works. Constructed in 1833, on the site of a drained withy bed, by the middle of the nineteenth-century it was illuminating 124 street lamps.

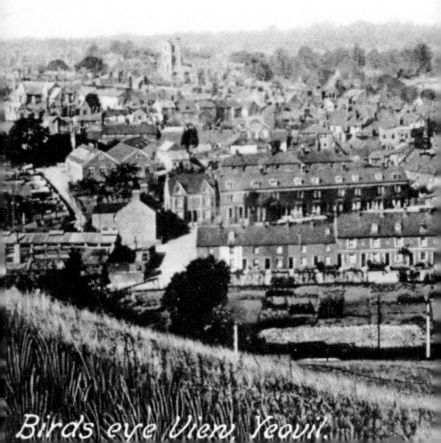

Birds eye View, Yeovil.

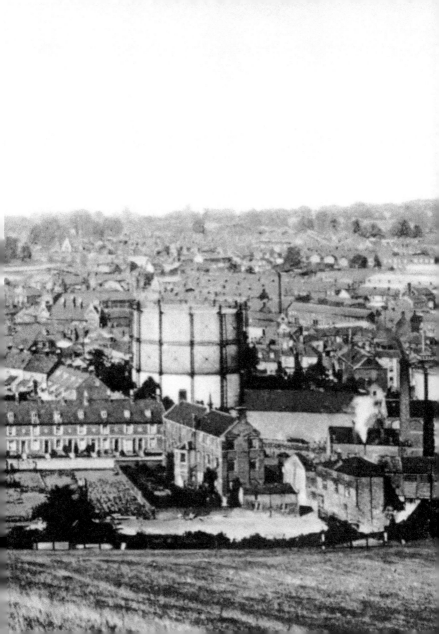

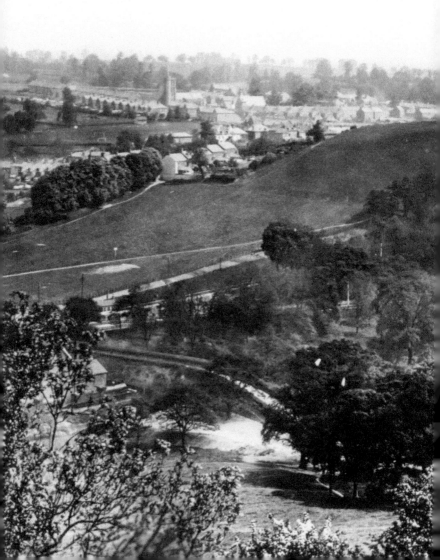

View from Summerhouse Hill, Yeovil.

44. VIEW TOWARDS WYNDHAM HILL
FROM SUMMERHOUSE HILL, *c.* 1910

The Parish Church of St Michael & All Angels, visible in the distance, was consecrated in 1897. Below Wyndham Hill flows the River Yeo, with the connecting line (opened 1857), between Yeovil Town and Yeovil Pen Mill stations, running in a cutting alongside. Since the line's closure in 1968, it has been converted into an attractive foot-and-cycle path within Yeovil Country Park. Wyndham Hill (named after a prominent local family), used to be known as Windmill Hill – though no trace of such a structure has ever been discovered.

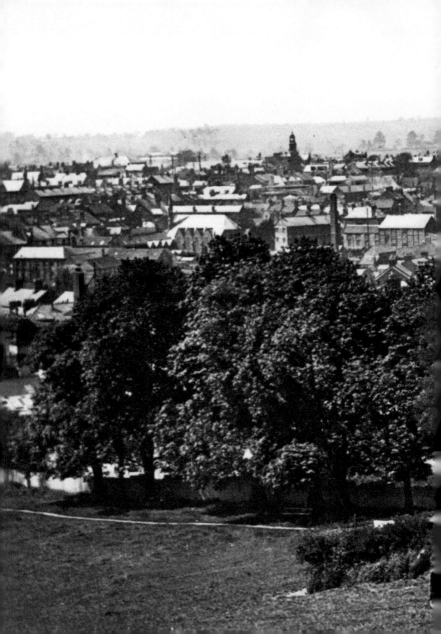

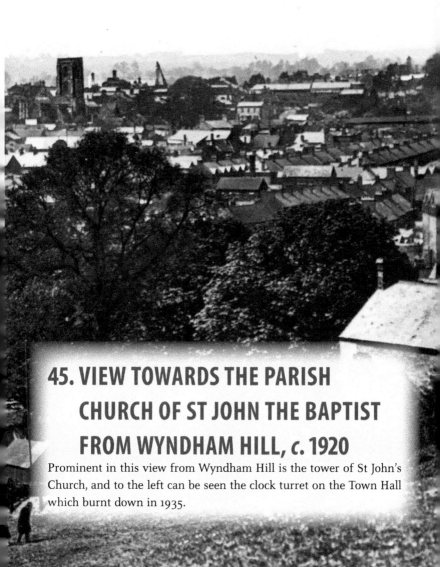

45. VIEW TOWARDS THE PARISH CHURCH OF ST JOHN THE BAPTIST FROM WYNDHAM HILL, *c.* 1920

Prominent in this view from Wyndham Hill is the tower of St John's Church, and to the left can be seen the clock turret on the Town Hall which burnt down in 1935.

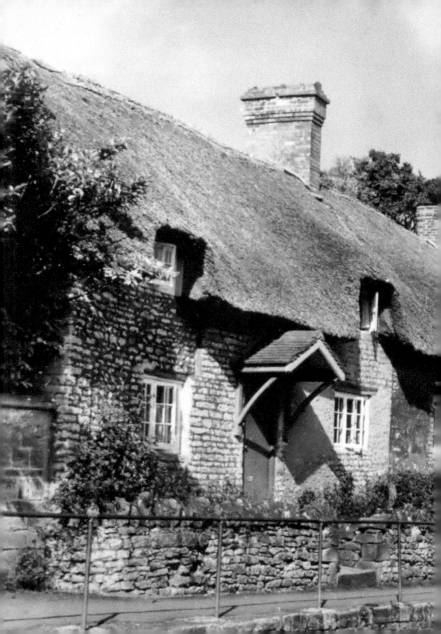

46. PRESTON ROAD THATCHED COTTAGES, *c.* AUGUST 1947

The parish of Preston Plucknett was absorbed into the Borough of Yeovil in 1929, but managed to retain much of its village character until the 1970s when large-scale residential, business and retail development spread into the area. Until some forty years ago, these thatched cottages stood near St James' Church, but were demolished for road widening.

ACKNOWLEDGEMENTS

The authors would like to express their appreciation to the following individuals and organisations, who materially assisted in the compilation of this book:

Allan Collier, Roger Grimley, Derek Phillips and Mike Shorter, AgustaWestland, South Somerset District Council and Yeovil Library.

(Yet again, the patience and forbearance of our respective spouses, Bernie Ansell and Margaret Sweet, is acknowledged with grateful thanks.)